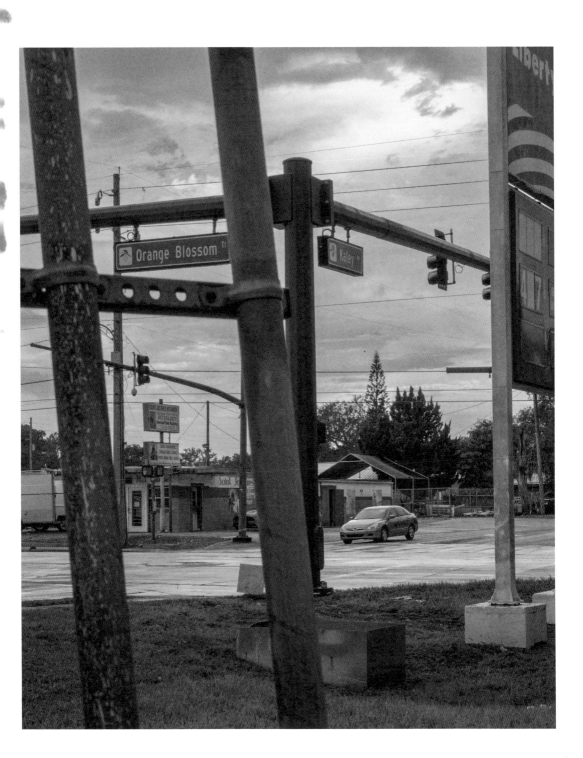

JOSHUA LUTZ

Orange

Blossom

Trail

GEORGE SAUNDERS

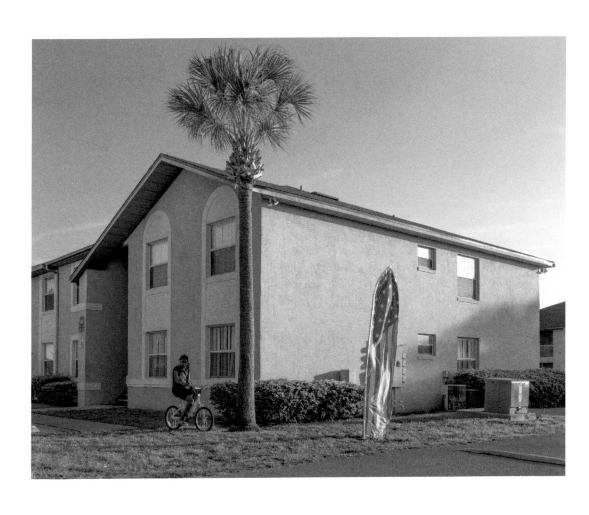

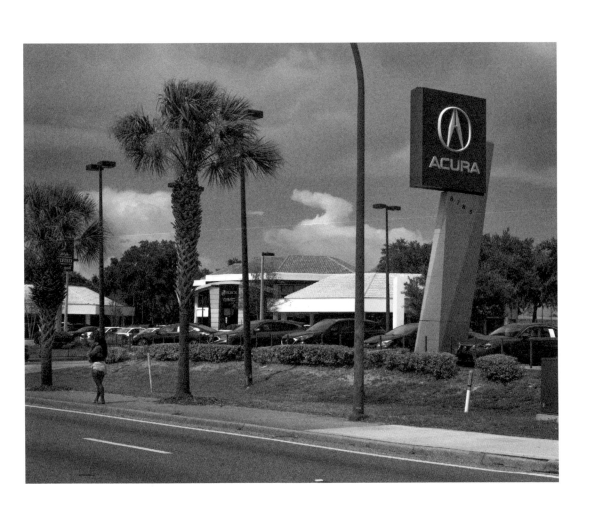

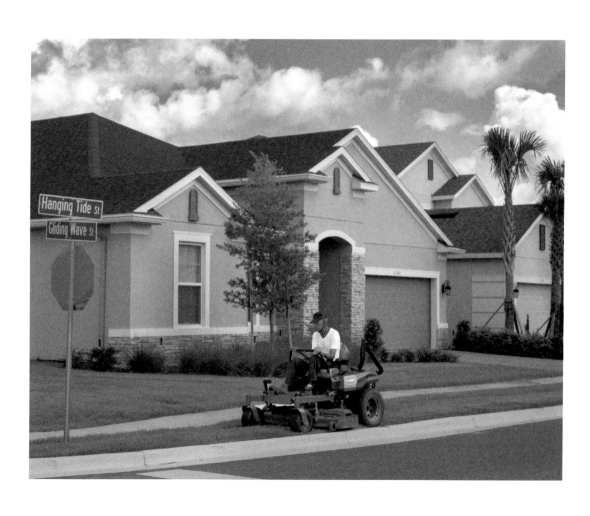

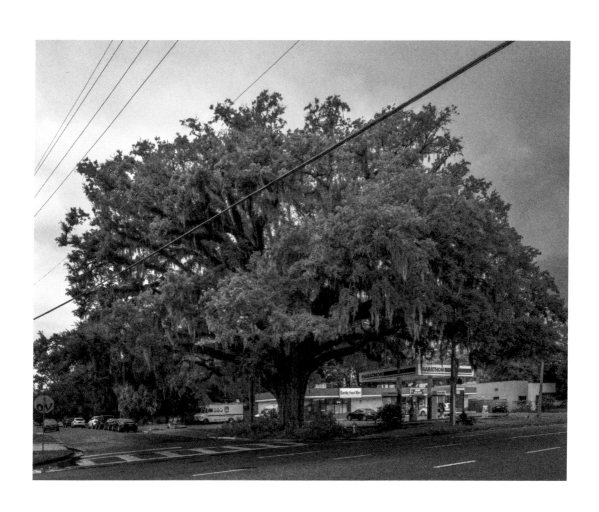

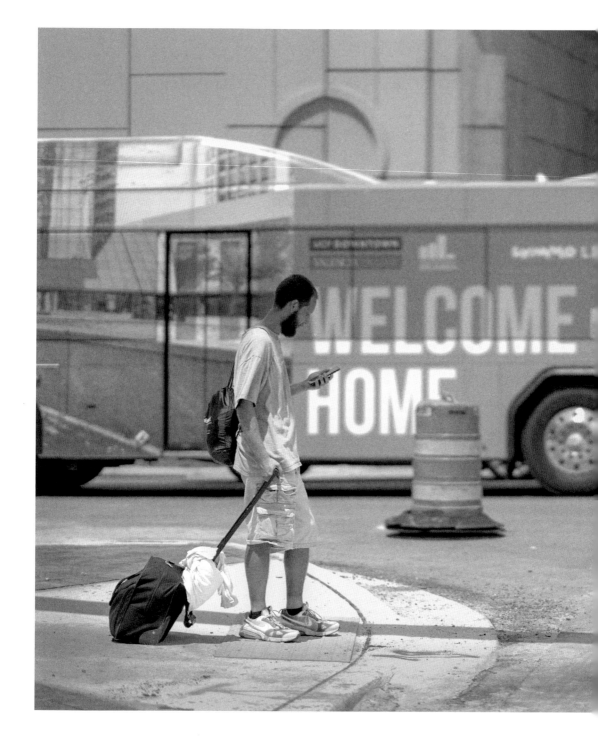

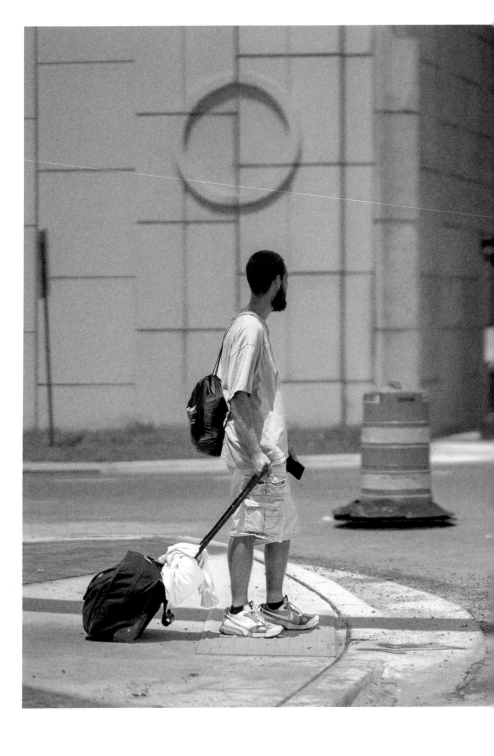

THOUGHT
EXPERIMENT

Imagine the following scenario: Two babies are born at precisely the same moment. Baby One is healthy, with a great IQ and all its limbs and two kind, intelligent, nondysfunctional parents. Baby Two is sickly, not very bright, is missing a limb or two, and is the child of two self-absorbed and stupid losers, one of whom has not been seen around lately, the other of whom is a heroin addict.

Now imagine this scenario enacted a million times.

Now imagine those two million babies leaving the hospital and beginning to live their lives.

Statistically, the Baby Ones are going to have a better time of it than the Baby Twos. Whatever random bad luck befalls the Babies, the Baby Ones will have more resources with which to engineer a rebound. If a particular Baby One turns out to be, say, schizophrenic, he or she will get better treatment than the corresponding Baby Two, will be generally safer and better-cared-for, will more likely have a stable home to return to. Having all his limbs, he can go where he needs to go faster and easier. Ditto if Baby One is depressed, or slow-witted, or wants to be an artist, or dreams of having a family and supporting that family with dignity.

A fortunate birth, in other words, is a shock absorber.

Now we might ask ourselves: What did Baby One do to deserve this fortunate birth? Or, conversely, what did Baby Two do to deserve the unfortunate birth? Imagine the instant before birth. Even then, the die was cast. Baby Two has done nothing, exerted no will, and yet the missing limb is already missing, the slow brain already slow, the undesirable parents already undesirable. Now think back four months before birth. Is the baby any more culpable? Six months before birth? At the moment of conception? Is it possible to locate the moment when Baby Two's "culpability" begins?

Now consider a baby born with the particular neurologic condition that will eventually cause him to manifest that suite of behaviors we call "paranoia." His life will be hell. Suspicious of everyone and everything, deeply anxious, he will have little pleasure, be able to forge no deep relationships. Now here is that baby fifteen seconds after conception. All the seeds of his future condition are present (otherwise, from what would it develop?). Is he "to blame"? What did he do, what choices did he make, that caused this condition in himself? Clearly, he "did" nothing to "deserve" his paranoia. If thirty years later, suspecting that his neighbor is spying on him, he trashes the neighbor's apartment and kills the neighbor's cat with a phone book, is he "to blame"? If so, at what point in his long life was he supposed to magically overcome/transcend his condition, and how?

Here, on the other hand, is a baby born with the particular neurologic condition that will eventually cause him to manifest that suite of behaviors we call "being incredibly happy." His life will be heaven. Everything he touches will turn to gold. What doesn't turn to gold he will use as fodder for contemplation, and will be the better for it. He will be able to love and trust people and get true pleasure from them. He is capable and self-assured, and using

his abilities, acquires a huge fortune and performs a long list of truly good deeds. Now here is that baby fifteen seconds after conception. All the seeds of his condition are present (otherwise, from what would it develop?). Can he, justifiably (at fifteen seconds old), "take credit for" himself? What did he do, what choices did he make, that caused this condition of future happiness to manifest? Where was the moment of the exertion of will? Where was the decision? There was no exertion of will and no decision. There was only fulfillment of a pattern that began long before his conception. So if, thirty years later, in the company of his beautiful wife, whom he loves deeply, Baby One accepts the Nobel Prize, then drives away in his Porsche, listening to Mozart, toward his gorgeous home, where his beloved children wait, thinking loving thoughts of him, can he justifiably "take credit" for any of this?

You would not blame a banana for being the banana that it is. You would not expect it to have autocorrected its bent stem or willed itself into a brighter shade of yellow. Why is it, then, so natural for us to blame a person for being the person she is, to expect her to autocorrect her shrillness, say, or to will herself into a perkier, more efficient person?

I now hear a voice from the gallery, crying: "But I am not a banana! I have made myself what I am! What about tenacity and self-improvement and persisting in our efforts until our noble cause is won?" But it seems to me that not only is our innate level of pluck, say, hardwired at birth, but also our ability to improve our level of pluck, as well as our ability to improve our ability to improve our level of pluck. All of these are ceded to us at the moment that sperm meets egg. Our life, inflected by the particulars of our experience, scrolls out from there. Otherwise, what is it, exactly, that causes Person A, at age forty, to be plucky and Person B, also forty, to be decidedly nonplucky? Is it some failure of intention? And at what point, precisely, did that failure occur?

The upshot of all of this is not a passive moral relativism that makes the bearer incapable of action in the world. If you repeatedly come to my house and drive your truck over my chickens, I had better get you arrested or have your truck taken away or somehow ironclad or elevate my chickens. But I'd contend that my ability to protect my chickens actually improves as I realize that your desire to flatten my chickens is organic and comes out of somewhere and is not unmotivated or even objectively evil— it is as undeniable to who you are, at that instant, as is your hair color. Which is not to say that it cannot be changed. It can be changed. It must be changed. But dropping the idea that your actions are Evil, and that you are Monstrous, I enter a new moral space, in which the emphasis is on seeing with clarity, rather than judging; on acting in the most effective way (that is, the way that most radically and permanently protects my chickens), rather than on constructing and punishing a Monster.

If, at the moment when someone cuts us off in traffic or breaks our heart or begins bombing our ancestral village, we could withdraw from judging mode, and enter this other, more accepting mode, we would, paradoxically, make ourselves more powerful. By resisting the urge to reduce, in order to subsequently destroy, we keep alive—if only for a few seconds more—the possibility of transformation.

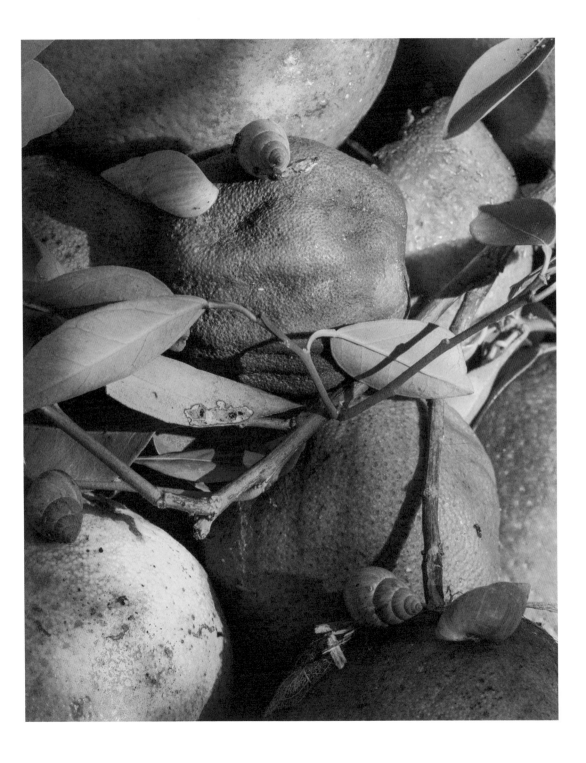

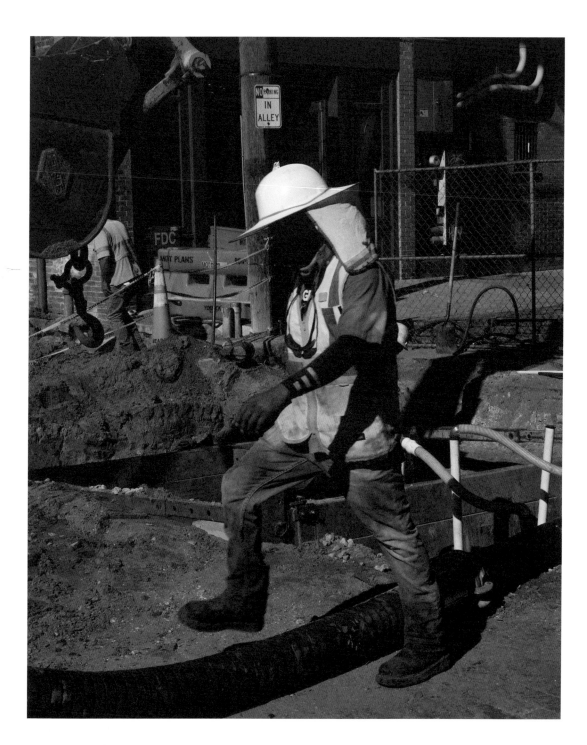

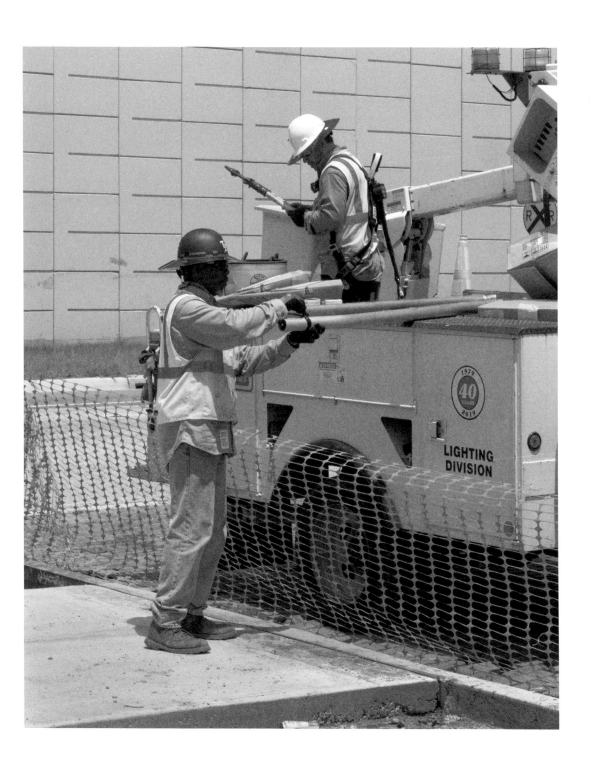

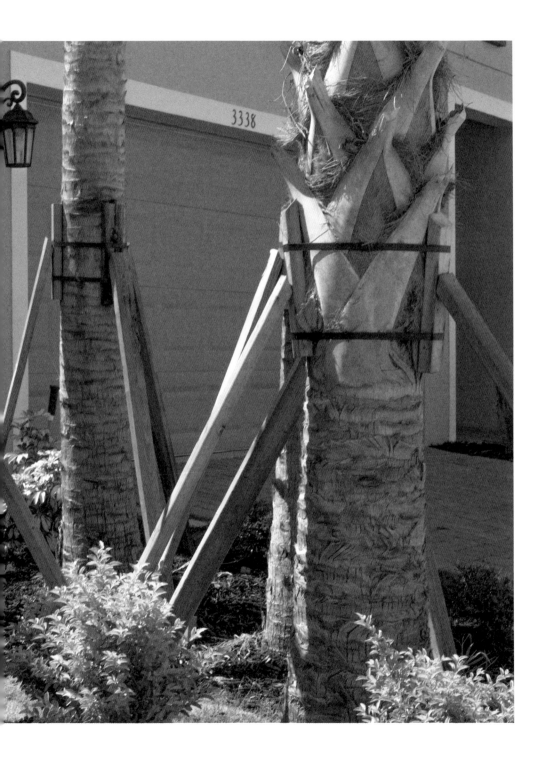

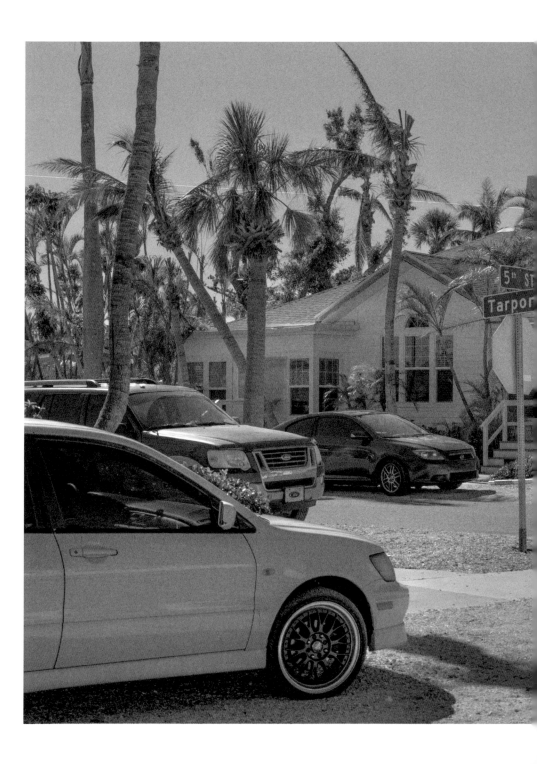

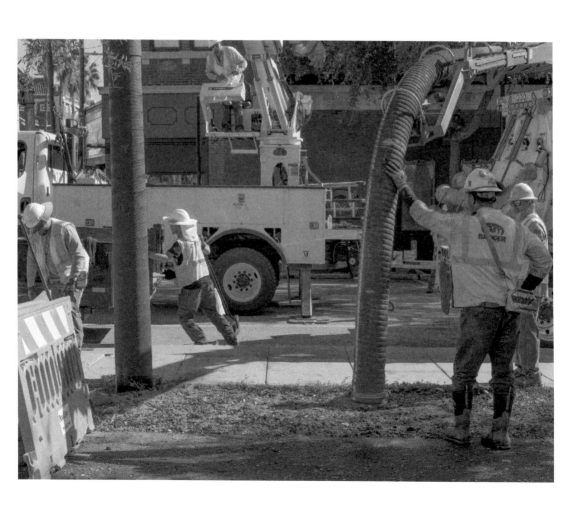

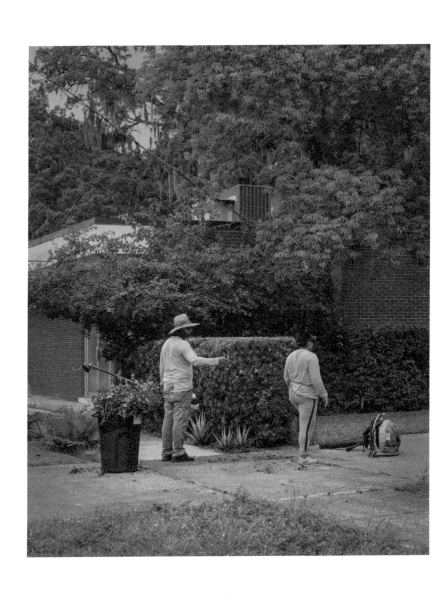

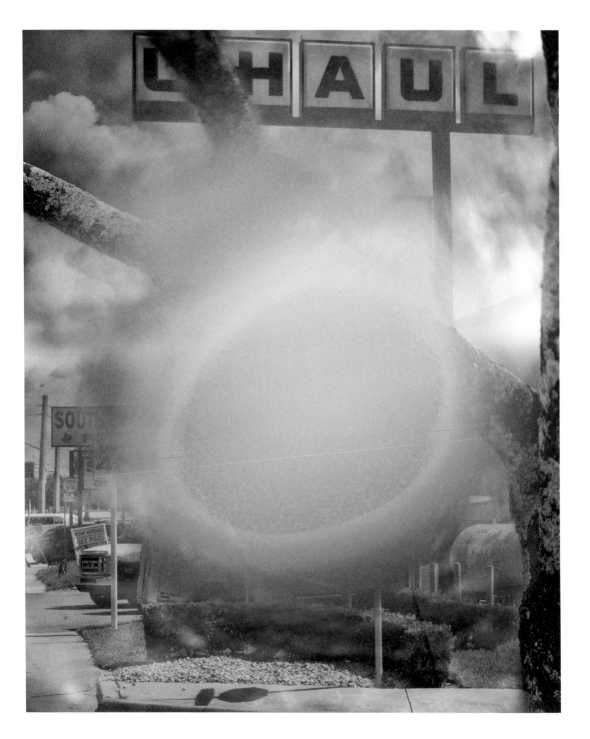

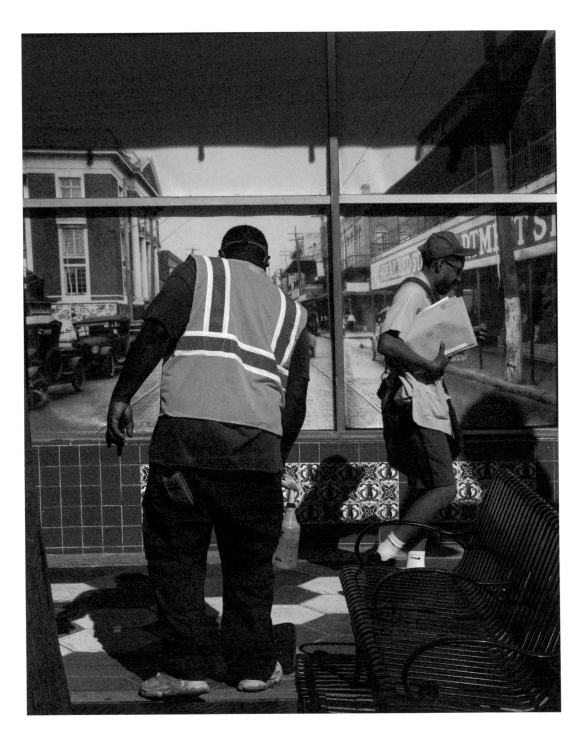

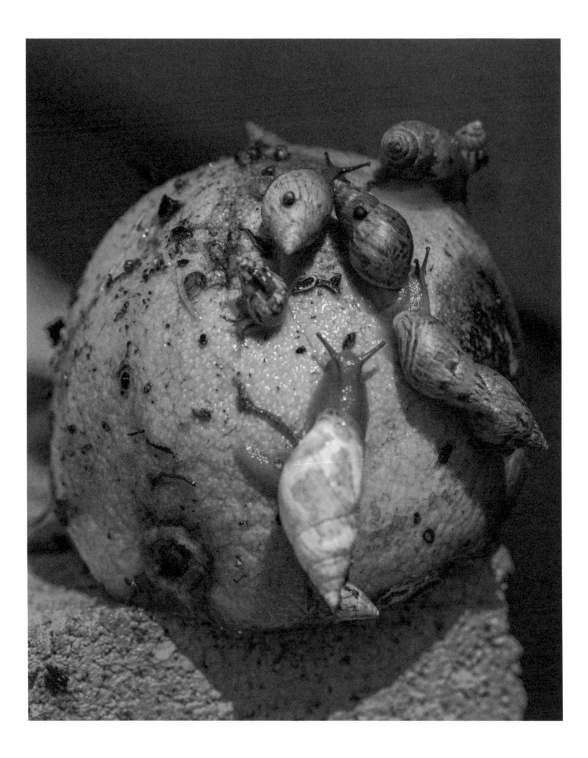

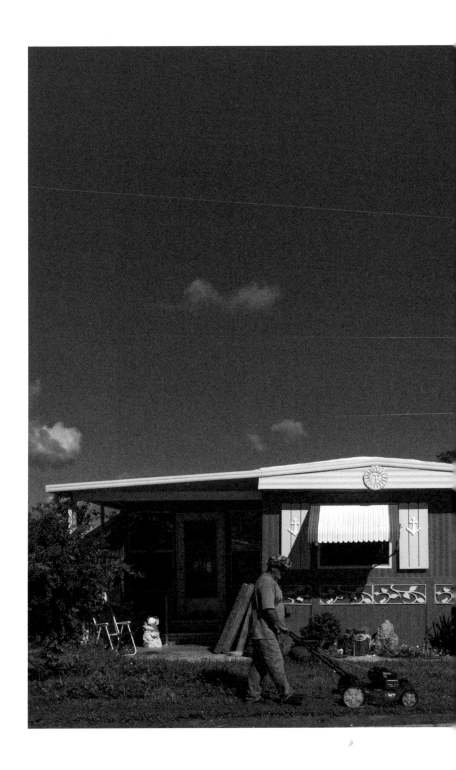

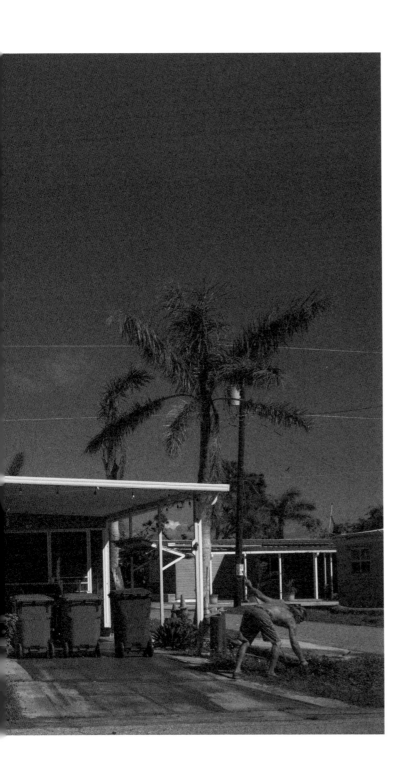

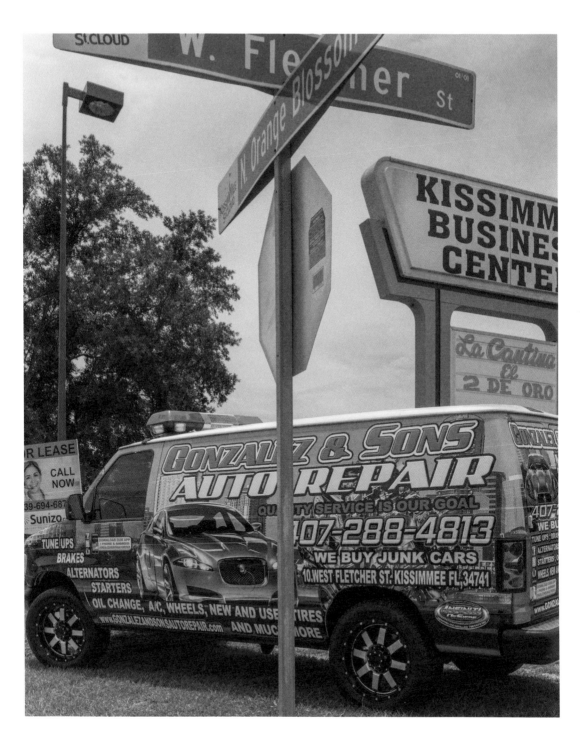

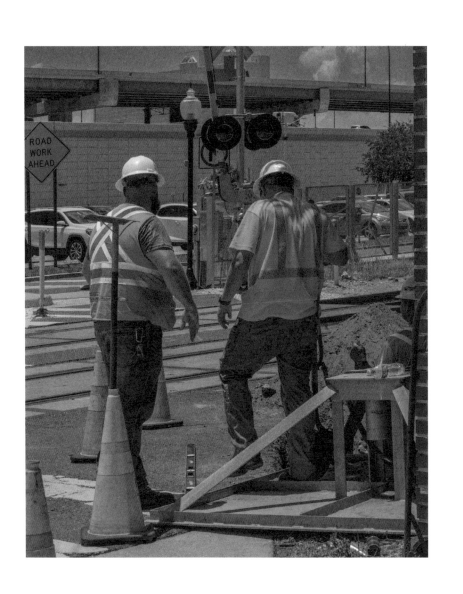

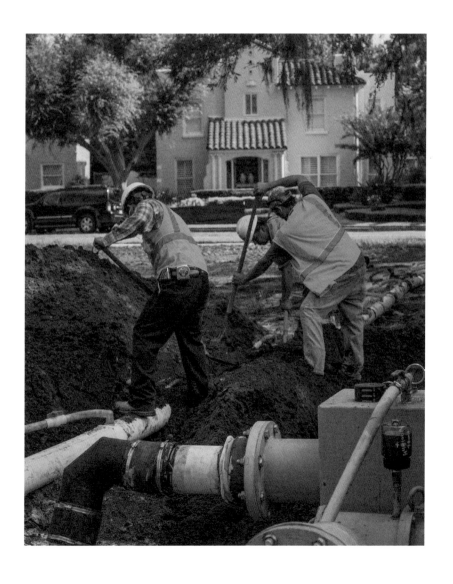

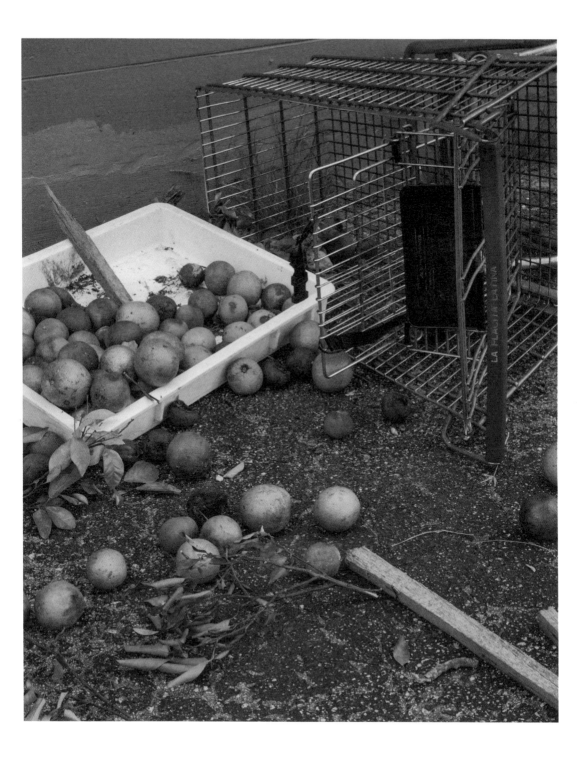

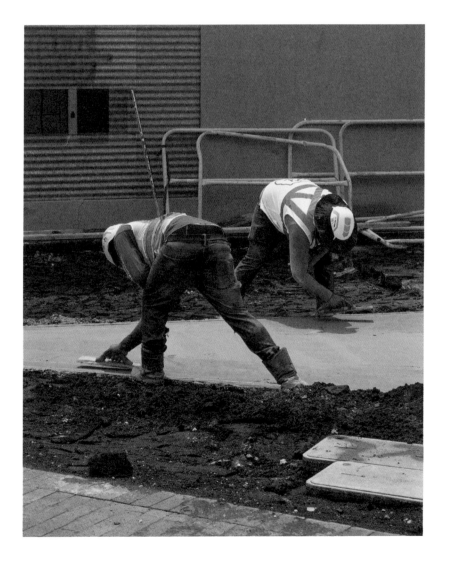

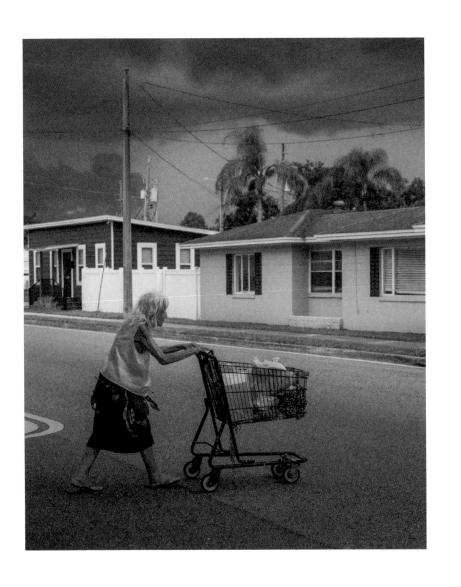

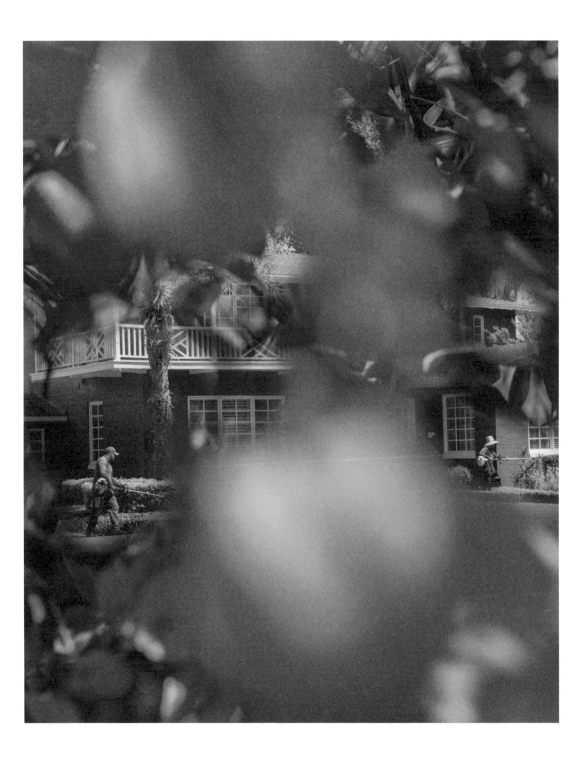

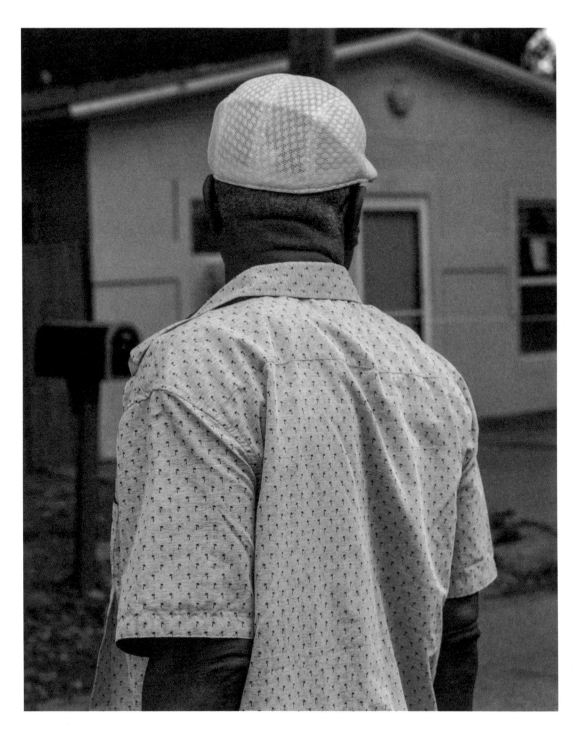

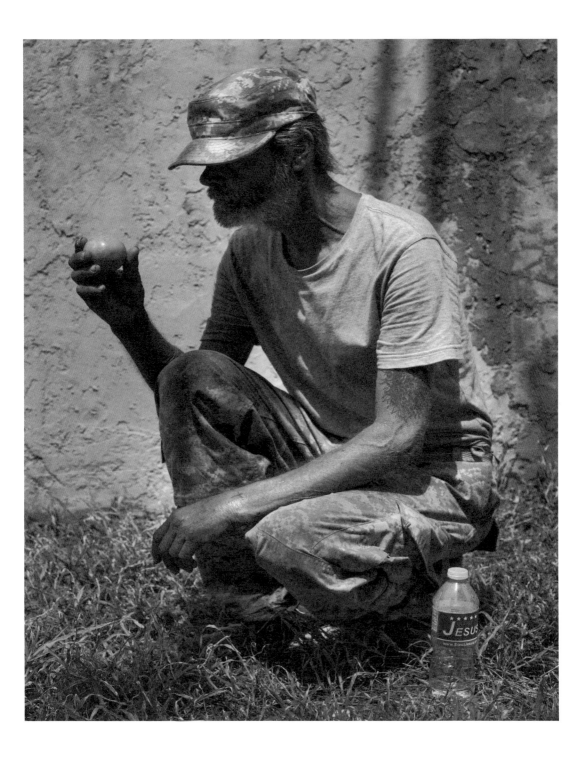

EXHORTATION

MEMORANDUM DATE: Apr 6
TO: Staff
FROM: Todd Birnie, Divisional Director
Re: March Performance Stats

I would not like to characterize this as a plea, although it may start to sound like one (!). The fact is, we have a job to do, we have tacitly agreed to do it (did you cash your last paycheck, I know I did, ha ha ha). We have also—to go a step further here—agreed to do the job well. Now we all know that one way to do a job poorly is to be negative about it. Say we need to clean a shelf. Let's use that example. If we spend the hour before the shelf cleaning talking down the process of cleaning the shelf, complaining about it, dreading it, investigating the moral niceties of cleaning the shelf, whatever, then what happens is, we make the process of cleaning the shelf more difficult than it really is. We all know very well that that "shelf" is going to be cleaned, given the current climate, either by you or the guy who replaces you and gets your paycheck, so the question boils down to: Do I want to clean it happy or do I want to clean it sad? Which would be more effective? For me? Which would accomplish

my purpose more efficiently? What is my purpose? To get paid. How do I accomplish that purpose most efficiently? I clean that shelf well and clean it quickly. And what mental state helps me clean that shelf well and quickly? Is the answer: Negative? A negative mental state? You know very well that it is not. So the point of this memo is: Positive. The positive mental state will help you clean that shelf well and quickly, thus accomplishing your purpose of getting paid.

What am I saying? Am I saying whistle while you work? Maybe I am. Let us consider lifting a heavy dead carcass such as a whale. (Forgive the shelf/whale thing, we have just come back from our place on Reston Island, where there were 1) a lot of dirty shelves, and 2) yes, believe it or not, an actual dead rotting whale, which Timmy and Vance and I got involved with in terms of the cleanup.) So say you are charged with, you and some of your colleagues, lifting a heavy dead whale carcass onto a flatbed. Now we all know that is hard. And what would be harder is: doing that with a negative attitude. What we found—Timmy and Vance and I—is that even with only a neutral attitude, you are talking a very hard task. We tried to lift that whale while we were just feeling neutral, Timmy and Vance and I, with a dozen or so other folks, and it was a no-go, that whale wouldn't budge, until suddenly one fellow, a former Marine, said that what we needed was some mind over matter, and gathered us in a little circle, and we had a sort of chant. We got "psyched up." We knew, to extend my above analogy, that we had a job to do, and got sort of excited about that, and decided to do it with a positive attitude, and I have to tell you, there was something to that, it was fun, fun when that whale rose into the air, helped by us and some big straps that Marine had in his van, and I have to say that lifting that dead rotting whale onto that flatbed with that group of total strangers was the high point of our trip.

So what am I saying? I am saying (and saying it fervently, because it is important): Let's try, if we can, to minimize the grumbling and self-doubt regarding the tasks we must sometimes do around here that maybe aren't on the surface all that pleasant. I'm saying let's try not to dissect every single thing we do in terms of ultimate good/bad/indifferent in terms of morals. The time for that is long past. I hope that each of us had that conversation with ourselves nearly a year ago, when this whole thing started. We have embarked on a path, and having embarked on that path, for the best of reasons (as we decided a year ago), wouldn't it be kind of suicidal to let our progress down that path be impeded by neurotic second-guessing? Have any of you ever swung a sledgehammer? I know that some of you have. I know that some of you did when we took out Rick's patio. Isn't it fun when you don't hold back, but just pound down and down, letting gravity help you? Fellows, what I'm saying is, let gravity help you here, in our workplace situation: Pound down, give in to the natural feelings that I have seen from time to time produce so much great energy in so many of you, in terms of executing your given tasks with vigor and without second-guessing and neurotic thoughts. Remember that record-breaking week Andy had back in October, when he doubled his usual number of units? Regardless of all else, forgetting for the moment all namby-pamby thoughts of right/wrong etc., etc., wasn't that something to see? In and of itself? I think that, if we each look deep down inside of ourselves, weren't we all a little envious? God, he was really pounding down and you could see the energetic joy on his face each time he rushed by us to get additional cleanup towels. And we were all just standing there like, Wow, Andy, what's gotten into you? And no one can argue with his numbers. They are there in our Break Room for all to see, towering above the rest of our numbers, and though Andy has failed to duplicate those numbers in the months since October,

1) no one blames him for that, those were miraculous numbers, and 2) I believe that even if Andy never again duplicates those numbers, he must still, somewhere in his heart, secretly treasure the memory of that magnificent energy flowing out of him that memorable October. I do not honestly think Andy could've had such an October if he had been coddling himself or entertaining any doubtful neurotic thoughts or second-guessing tendencies, do you? I don't. Andy looked totally focused, totally outside himself, you could see it on his face, maybe because of the new baby? (If so, Janice should have a new baby every week, ha ha.)

Anyway, October is how Andy entered a sort of, at least in my mind, de facto Hall of Fame, and is pretty much henceforth excluded from any real close monitoring of his numbers, at least by me. No matter how disconsolate and sort of withdrawn he gets (and I think we've all noticed that he's gotten pretty disconsolate and withdrawn since October), you will not find me closely monitoring his numbers, although as for others I cannot speak, others may be monitoring that troubling falloff in Andy's numbers, although really I hope they're not, that would not be so fair, and believe me, if I get wind of it, I will definitely let Andy know, and if Andy's too depressed to hear me, I'll call Janice at home.

And in terms of why is Andy so disconsolate? My guess is that he's being neurotic, and second-guessing his actions of October—and wow, wouldn't that be a shame, wouldn't that be a no-win, for Andy to have completed that record-breaking October and then sit around boo-hooing about it? Is anything being changed by that boo-hooing? Are the actions Andy did, in terms of the tasks I gave him to do in Room 6, being undone by his boo-hooing, are his numbers on the Break Room wall miraculously scrolling downward, are people suddenly walking out of Room 6 feeling perfectly okay again? Well we all know they are not. No one is walking out of Room 6 feeling perfectly okay.

Even you guys, you who do what must be done in Room 6, don't walk out feeling so super-great, I know that, I've certainly done some things in Room 6 that didn't leave me feeling so wonderful, believe me, no one is trying to deny that Room 6 can be a bummer, it is very hard work that we do. But the people above us, who give us our assignments, seem to think that the work we do in Room 6, in addition to being hard, is also important, which I suspect is why they have begun watching our numbers so closely. And trust me, if you want Room 6 to be an even worse bummer than it already is, then mope about it before, after, and during, then it will really stink, plus, with all the moping, your numbers will go down even further, which guess what: they cannot do. I have been told in no uncertain terms, at the Sectional Meeting, that our numbers are not to go down any further. I said (and this took guts, believe me, given the atmosphere at Sectional): look, my guys are tired, this is hard work we do, both physically and psychologically. And at that point, at Sectional, believe me, the silence was deafening. And I mean deafening. And the looks I got were not good. And I was reminded, in no uncertain terms, by Hugh Blanchert himself, that our numbers are not to go down. And I was asked to remind you—to remind us, all of us, myself included—that if we are unable to clean our assigned "shelf," not only will someone else be brought in to clean that "shelf," but we ourselves may find ourselves on that "shelf," being that "shelf," with someone else exerting themselves with good positive energy all over us. And at that time I think you can imagine how regretful you would feel, the regret would show in your faces, as we some-times witness, in Room 6, that regret on the faces of the "shelves" as they are "cleaned," so I am asking you, from the hip, to try your best and not end up a "shelf," which we, your former colleagues, will have no choice but to clean clean clean using all our positive energy, without looking back, in Room 6.

This was all made clear to me at Sectional and now I am trying to make it clear to you.

Well I have gone on and on, but please come by my office, anybody who's having doubts, doubts about what we do, and I will show you pictures of that incredible whale my sons and I lifted with our good positive energy. And of course this information, that is, the information that you are having doubts, and have come to see me in my office, will go no further than my office, although I am sure I do not even have to say that, to any of you, who have known me all these many years.

All will be well and all will be well, etc., etc.,

Todd

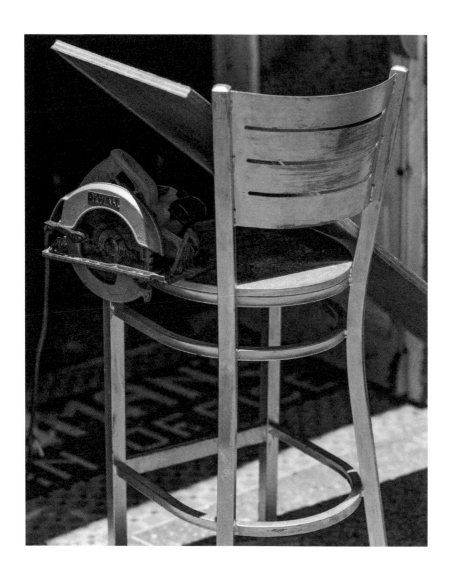

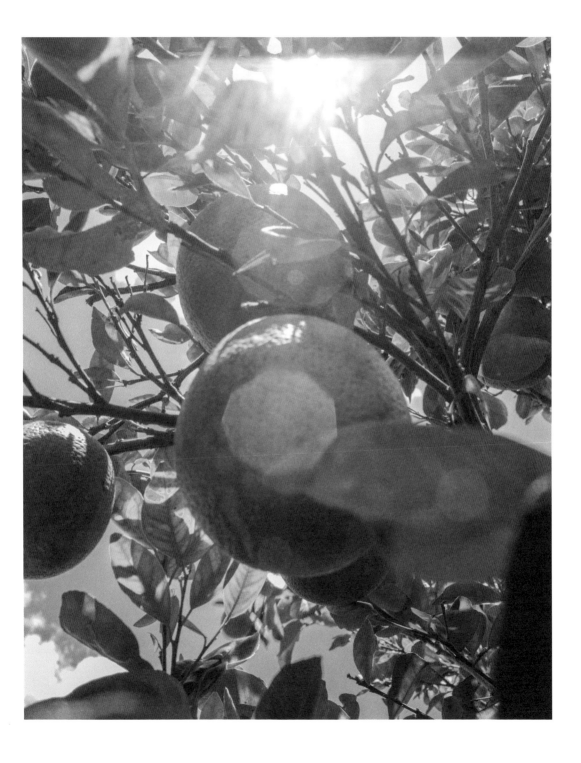

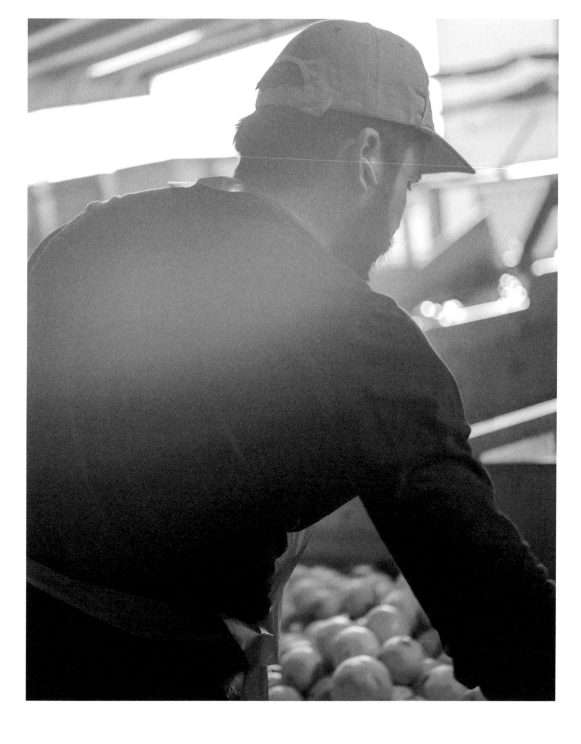

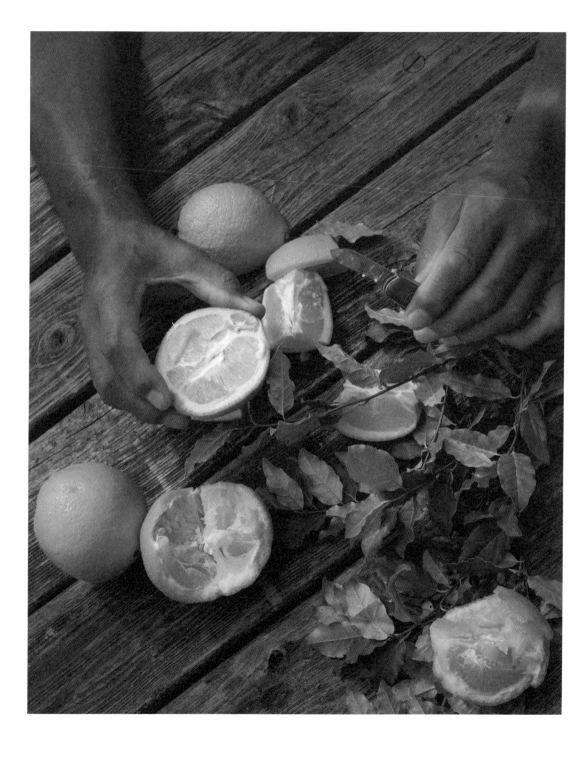

Uncle Jim took Betty and Billy
to a big building.
It was a packing house.
The men brought the oranges
and lemons from the grove.
They washed the fruit in warm
ater.
an it is," said Betty.

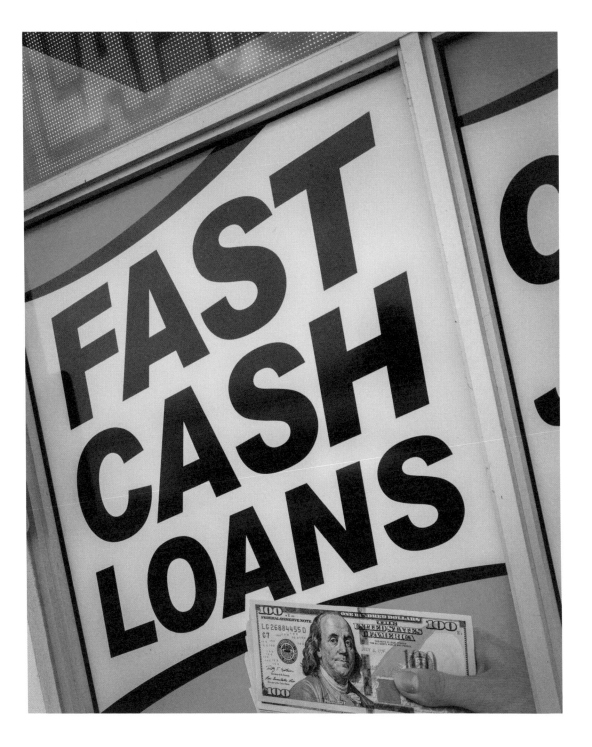

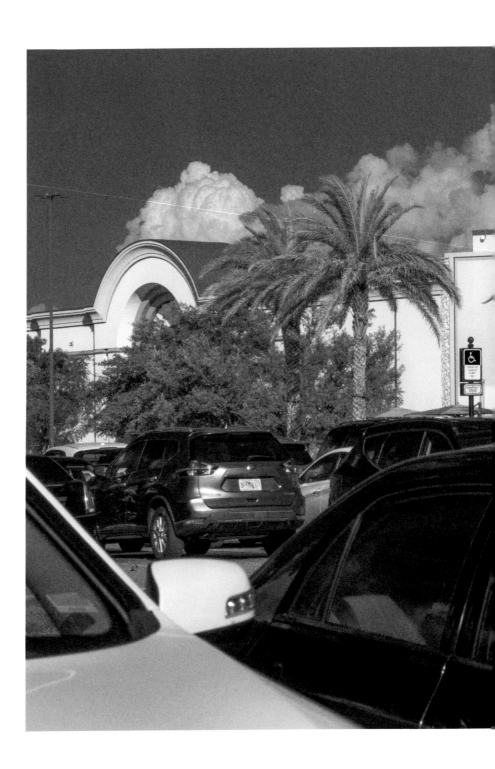

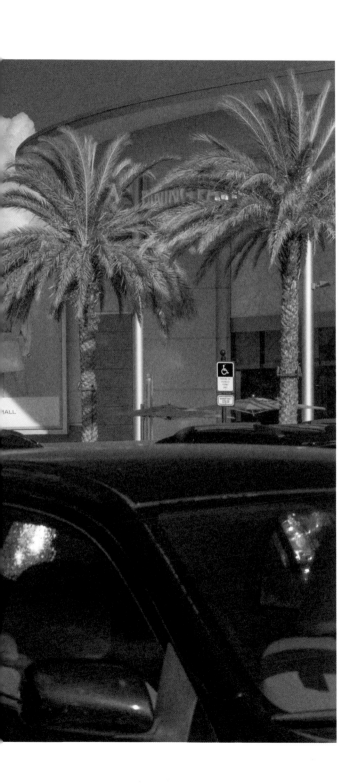

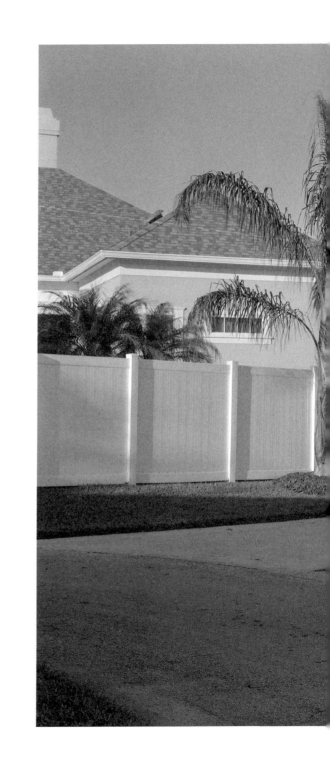

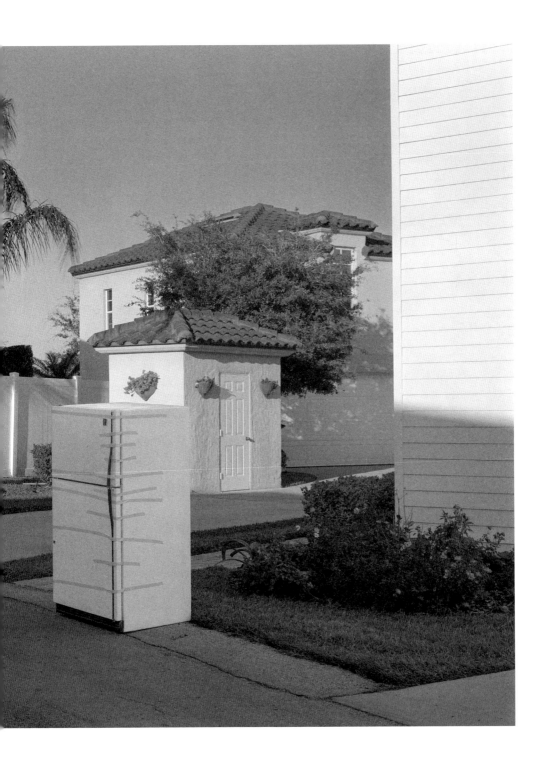

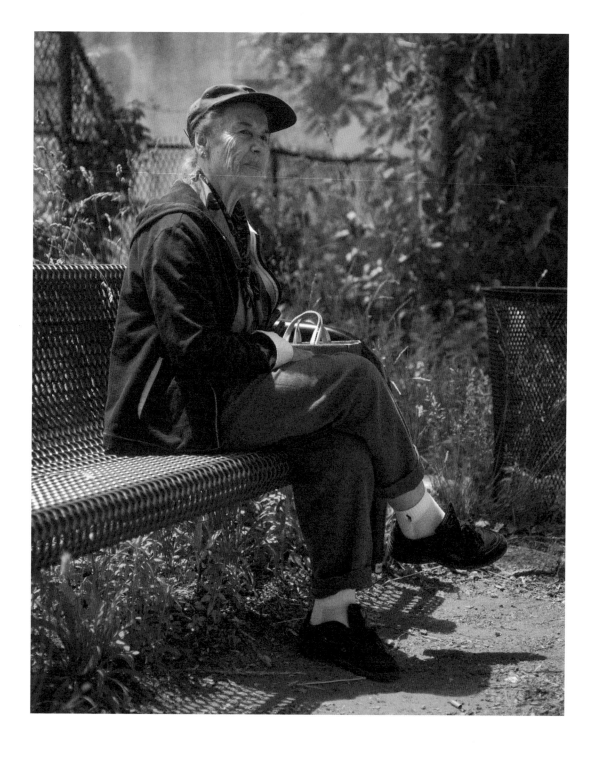

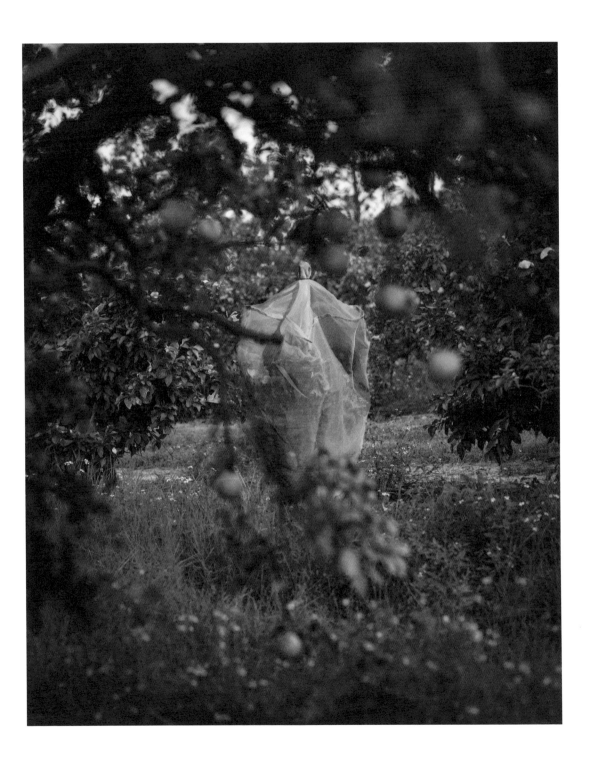

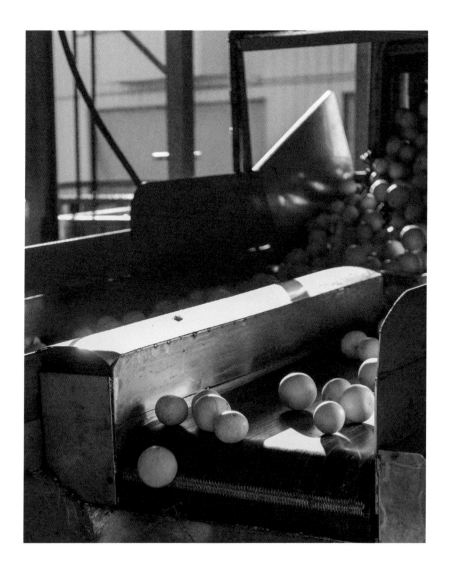

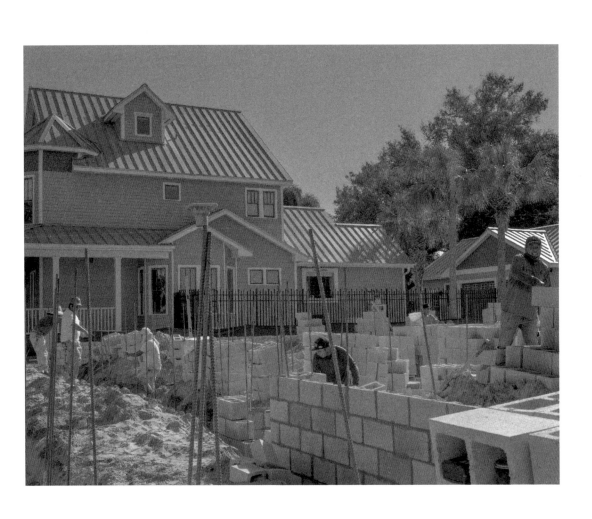

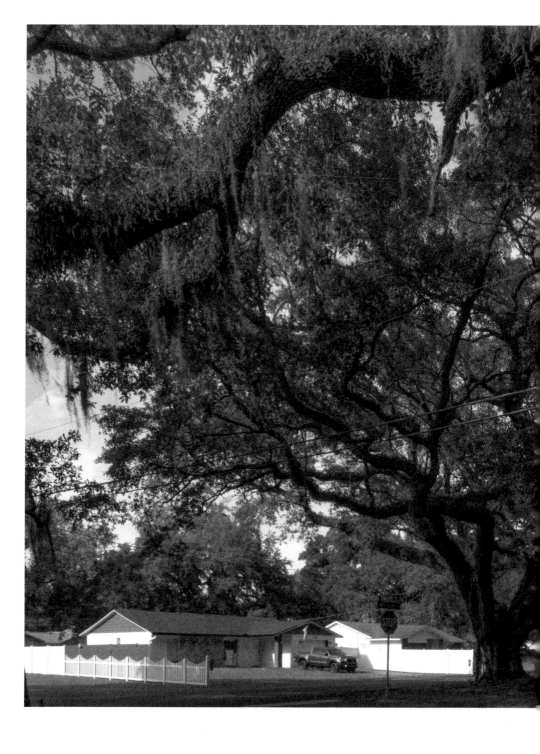

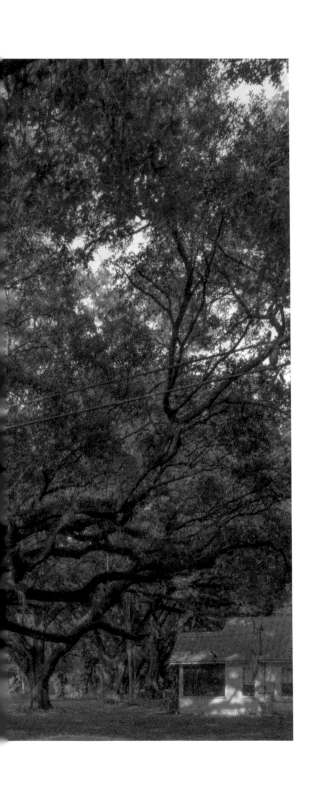

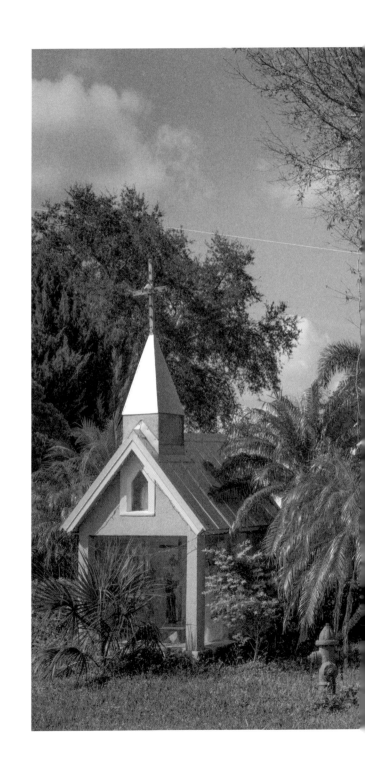

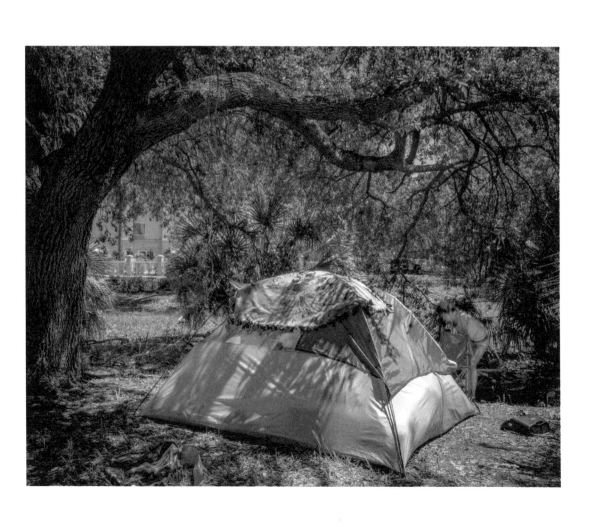

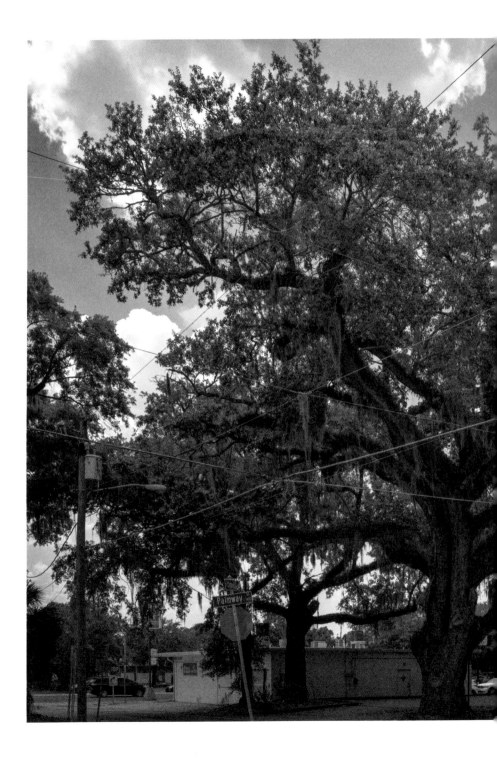

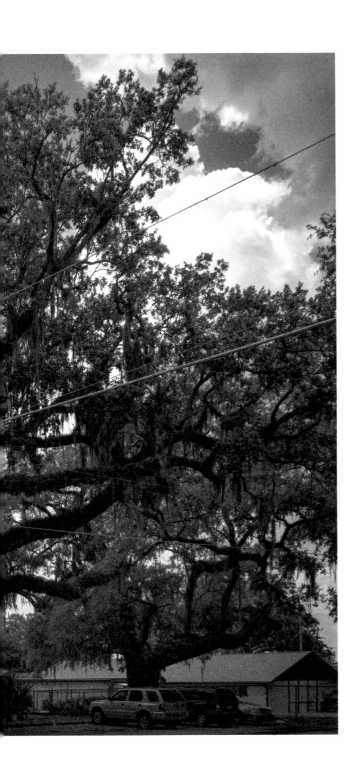

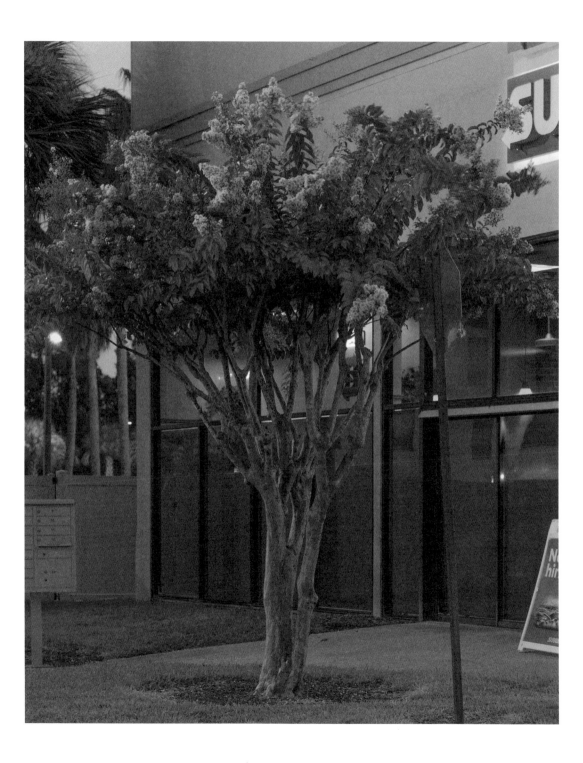

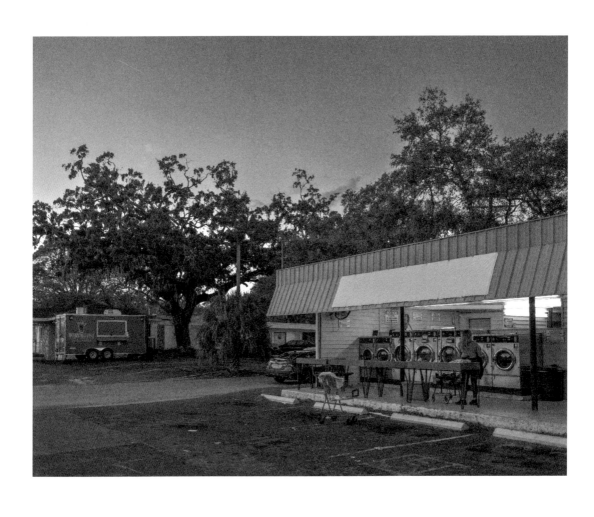

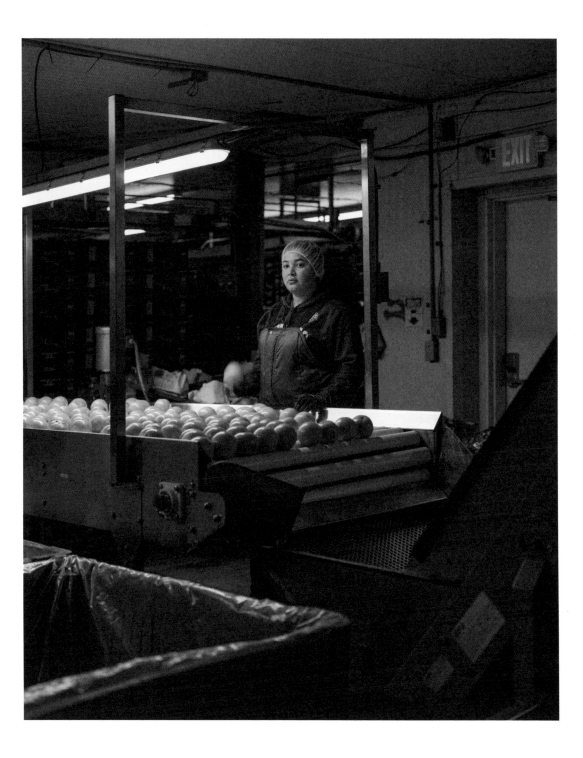

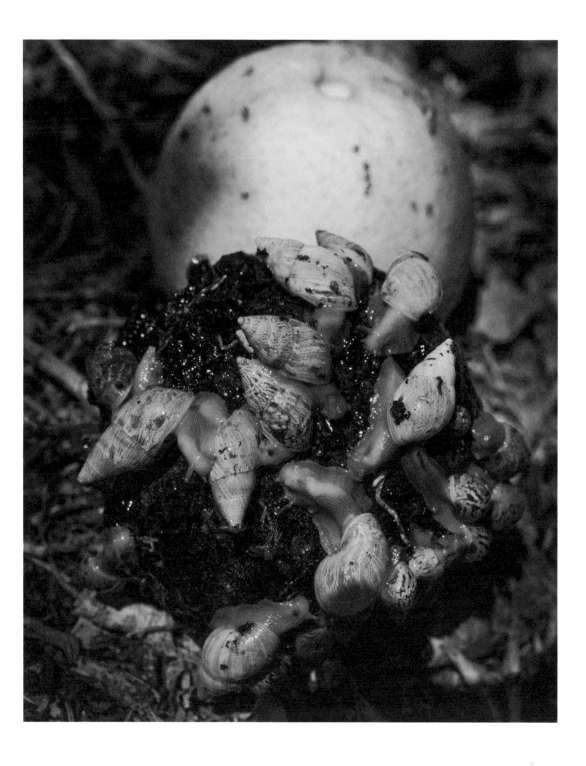

HAAA Yaah Gaa-DEE Waa-HAA-eh Naii-Haii
HAAA Yaah Gaa-DEE Waa-HAA-eh HAAA Yaah Gaa-DEE Waa-HAA-eh Nai-Haii
 Y W N
HOO-Oh Yaa-ah NAA-eh HAA-NeAh, Naiih-Yah-WOUh-NAAh This is what should
 Y W happend.
 U Y W
GeUh Gaa-DEE Waa-HA-eh Naiih-Yah-WOUh-NAAh
GeUh Gaa-DEE Waa-HA-eh Naiih-Yah-WOUh-NAAh Naii-Haiii
 HAAA GeUh Gaa-DEE Waa-HA-eh Naii-Haiii
HOO-Oh Yaa-ah NAA-eh HAA-NeAh HAA GeUh Gaa-DEE Waa-HA-eh Naii-Haiii

33. Yaah Gaa-DEE Waa-HA-eh Taii-Yii-AAh-HEE-YAAh she will not die
 Yaah Gaa-DEE Waa-HA-eh Taii-Yii-AAh-HEE-YAAh
 HAAA Yaah Gaa-DEE Waa-HA-eh Naii- Haiii The dead are asking
HOO-Oh Yaa-ah NAA-eh HAA-NeAh, HAAA Yaah Gaa-DEE Waa-HA-eh Naii-Yaiii ok show me
 HAy Ho?
 Questions
34 HAA-Gaa-JEE, Waa HA-EH HOOO-O-HOh D DO
 HAA-Gaa-JEE, Waa HA-EH HOOO-O-HOh, HAA HAA-Gaa-JEE-Wa-HAA HO-HO
 D DO
 HAA-Gaa-JEE, Waa HA-EH HOOO-O-HOh, HAA HAA-Gaa-JEE Wa-HAA, HO-HO "OKIWE
 HO-O Ya-a NA-A, HA-Heh, HAA HAA-Gaa-JEE Wa-HAA, HO-HO (I AM)
 And Khonored
35 YOHO-GEEh HEE-NeA, YO-O-GEEh HEE-NeA, YO-O-GEEh HEE-NeA-EaH, YOHO-GEE HEE To be part of
 YOHO-GEEh HEE-NeA, YO-O-GEEh, HEE-NeA, YO-O-GEEh HEE-NeA-EaH, YOHO-GEE HEE it.
 GEE HEE-NeA, YOO GEE HE HEE-NeA, YO-O-GEEh HEE-NeA-EaH, YOHO-GEE HEE Questions
 HI-I-YOO-O GEE HEE-NeA, HeAAA
 YOOO GEEh HEE-NeA, YO-O-GEEh HEE-NeA, YO-O-GEEh HEE-NeA HEE-NeA
 GEE HEE-NeA, YOO GEE-HE HEE-NeA, HII YOO-GEEh HEE-NeA HEE-NeA
 HI-I-YOO-O GEE HEE-NeA HeAAA.
 OPEN DOOR
 Ho you the living Okiwe Society
 women can
 repete as
 many times as
 they want
36 HOO: ZeAA NUU WAA GEE Yaa-a NAA HAAA Smokeing Pi-
 means woman
 HOOO ZeAA NUU WAA GEE Yaa-a NAA HAAA
 : HOOO ZeA-EAH NUU WAA GEE Yaa-a NAAA HAAA,
 WAAAh, HOO ZeAAh, HOO Yaa-a NAAA HAAA, NeAA HOO Yaaa NAAA HAAA, Hello
 wa Greetings
 S C To the Okiwe Sosiety
 HOO ZeAA NUU WAA GEE Yaa-a NAAH, NeAA HOO Yaaa NAAA HAAA A New Generation
 WAA-GEE Yaa-a NAAA HAAA

37 HOOO SeAAA-GeUUh WAAA-GEE Yaa-ah NAA HAAA
 HOOO SeAAA-GeUUh WAAA-GEE Yaa-ah NAA HAAA
 HOOO SeAA-eAh-GeUUh WAAA-GEE Yaa-ah NAA HAAA
 WAAAh Waah-ZeAAh GOOO-YeUUh-ah NAAA HAAA
 HOOO SeAA-GeUUh WAA-GEE Yaa-ah NAA, NeAA HOOO-Yaaa-NAAA HAAA,
 WAAA-GEEE Yaaa-ha-NAAA HAAAA

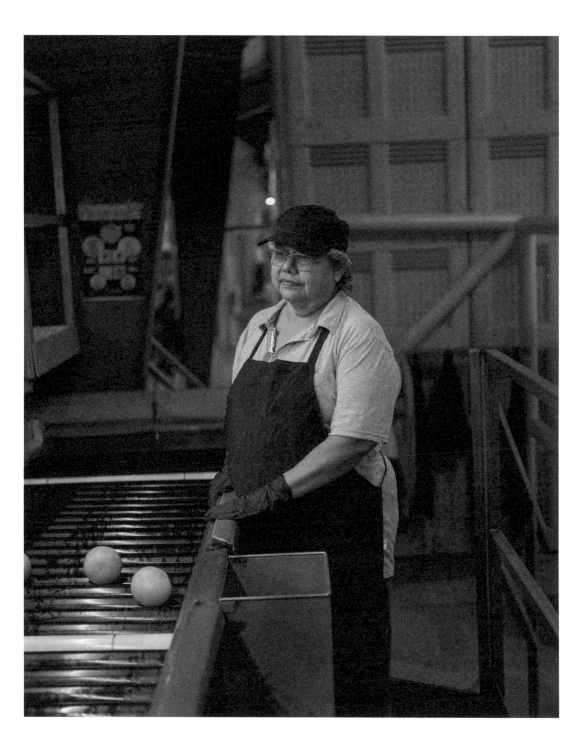

MY HOUSE

Who would sell a gem like that? Well, Mel Hays. That was his name. Per Jordan at Hillside Realty. He was mad to sell. Sick wife, had just retired, couldn't keep the place up. Odd duck, Jordan said, required a personal meeting with anyone thinking of offering.

My God, we hit it off. Hays was big, shaggy, friendly, funny: the brother I'd never had. He'd worked for the village, had a thing for history. Me too, I said, and we shared a mutual history-nerd blush. What I loved about the place were exactly the things he loved about it: the barn (built in 1789); the six leaning hitching posts, each capped with a different serpent face; the oak from which the wrong man had been hung for treason; the smaller oak planted over the spot where the man's body lay buried for fifteen years before his family came to dig him up.

Ghosts? I asked.

Ho ho, he said, touching my arm, meaning: There's more to say on that matter, friend.

The door to the room where the wife was sick stayed closed. But the rest of the house, Good Lord. Bookshelves everywhere, of mahogany and maple, strange half-rooms stuffed with cased artifacts: a Tahitian oar, the neck of a fiddle played at Antietam,

a child's jacket from the time of Washington, smudged, just there, with mud from the period.

Amazing, I said.

We've been lucky, he said.

The interior showed signs of the neglect associated with the wife's illness and their shortage of funds and I resolved, in the name of this surprising warmth between us, to meet his asking price.

Just because.

Because I had it.

By the time we came back out onto the wide porch I had so admired from the road we were friends and the house, it seemed, was mine. There's a family of foxes who come to sit over there in the arbor, he said. And: Those dogwoods flower white like crazy in early April. And: You'll want to watch the basement walls for cracks in the winter.

It had a manor-house feeling and sat high on a hill over-looking the quaint little village.

I thought of my friends moving awed through the wide front hall, craning their necks up that mysterious winding stairwell, and then I'd guide them upstairs to the room where, in such-and-such a year, So-and-so had endured a difficult childbirth. I'd do research on the house and compile my findings in a leather-bound book, to be placed in the pentagonal recess in the narrow hall that led to the former servants' quarters. All my life I'd believed I'd someday live in a place like this, had suffered the distance between such places as they existed in my imagination and the places in which I'd actually lived (before Kay, with Kay, after Kay left): their low ceilings, ugly heat vents, hollow pine doors. To live here would be, I imagined, a sort of exorcism of all the limitations I'd ever felt. Here one sensed—craftsmanship, yes, but also, my God— the past, the living past: the parties held, the food served, the dust motes of 1862, the war goodbyes of 1917, the whispered

late-night dramas that had forever altered the lives of the people who'd once moved down these very hallways and now lay buried in the village graveyard I'd visited on the way over, trailing my hands over the mossy stones, reading names aloud, thinking, poor bastards, you no longer walk in the sun.

Hays paused us at an orchard. Apples and pears had once hung thick on the trees and carpeted the ground, he said. Now, well, no. There was some sort of disease. He'd been preoccupied.

And he gestured up at the window of the sickroom of the wife.

I'll hire a gardener, I thought, get it back to health. He seemed to read my mind and the look on his face said: You showing up here, now, to steward this beloved place, and with the means to do so, proves that such a thing as good fortune truly exists.

Our handshake seemed to mean: Let's burn through the technicalities, get the thing done.

It kills me, he said. To think of losing this place forever.

I get that, I said.

And I did. My mind leapt ahead, to that sad future someday when I, too, would lose it forever.

It's heaven, he said. It's been a heaven for the two of us.

I believe it, I said.

Maybe, he said, and a look came over his face, a self-doubting look, and I found myself wanting to offer whatever he needed.

It was strange, very strange, to like someone so much on a first meeting.

Go on, I said.

Maybe I could drop by now and then, he said.

And I thought: Well, yes, sure, it would be good to see him once in a while.

But then he went on.

Spend a day or two, he said. Stay in the guest room, maybe.

I didn't say no. I didn't. But a look must have passed over my face. Wouldn't a look have passed over yours? Dropping by... well, maybe. But spending "a day or two"? "In the guest room"? Did he mean my guest room or theirs? The room they had designated or the one I soon would—

It was one too many, somehow.

Then I thought: He won't take me up on it once he's out; he's just talking, to be comforted.

Recovering my manners, I said yes, of course he would be welcome, they would, always welcome, anytime at all.

But now there was a look on his face.

Anytime at all, I said. Truly.

He gave me a pat on the back, said we'd see how things went, made a vague, despairing gesture at my car, as in: There it is, you know where it is, off you go.

I thought: Too bad. But, then again, where is it written we have to be friends?

I sat in the car awhile, looking up at the house, already loving it more than I'd ever loved any place in my life.

I called Jordan, had her make the full-price offer, plus ten percent. Next morning, she called back, mystified. It seemed he'd changed his mind. About selling. It was the oddest thing, she said. No way he could afford to keep the place. His agent said the same. Together, they were trying to figure out what the hell had gone wrong. Hays was on a tiny pension, his wife was dying, there were medical bills, the house had been on the market for two years, mine was the first offer.

Did you say something? she asked. Do something?

He said he sometimes might want to come and stay over, I said. Like, overnight. And I just, you know, hesitated.

That's weird, she said. I mean, sounds like you were well within your rights.

I think so, I said. I didn't say no. I just...

And that did it? she said. Wow.

We went back, offered more, then more, until, finally, we were offering more than a third again above his original asking price.

But it was still a no.

In January the wife died. I sent a condolence card, with an offer to meet for coffee, got no response. I started driving by now and then just to torture myself. That spring, the roof of the side library collapsed after a tree fell on it. Soon the tree had become part of the house. After a heavy summer rain, the front porch I'd loved so much sank into the earth a foot or so on the south end; three of its columns bowed and cracked. Then one gave way and the two halves of it lay in the yard and the lip of the roof there drooped and you could see into the rusty, filth-packed gutter. By October the grand front lawn was overgrown and wild turkeys were foraging there. You'd see them, big and ugly, strutting around like dinosaurs.

Some nights a single light showed from an upstairs window.

Finally I wrote him a letter. Was there not some way to fix this? Wasn't it in our mutual interest to talk the thing through, come to some agreement? I got no answer, wrote another. We're both good people, I wrote, this is a win-win, can't we let bygones be bygones? I am deeply sorry, I said, that I did not respond more generously in the moment. I was just taken aback. Briefly. I didn't say no, after all; I only hesitated. Was that an unforgivable sin? Surely a person could forgive the mistake of an instant?

Nothing.

A third letter: Wasn't he ashamed of himself, for being so obstinate? Was this not, what we two old men were enacting, exactly what has ailed the world since time immemorial? Did he really think it was appropriate to make the sale of a property contingent on installing himself as a sort of permanent possible houseguest? What sort of dream world was he living in?

No answer.

A fourth: You'll die, I'll get the house, trust me. Why not sell now? Use the money to live a better life than the tormented one it would appear you are living, sitting up there lonely and bitter, letting that beautiful place, a place you loved, a place the two of you loved, go to seed. Shame on you, I hope you're enjoying the fruits of your arrogance, you stubborn, mean-spirited old bastard.

That one, to my credit, I never sent. I wadded it up, burned it over the stove.

I had fallen ill. I am ill now. My time is short. I burned that letter to prepare myself to face what is coming with as pure a heart as I can manage.

I need to write another. Of course. I know that. If only for my own benefit.

I am truly sorry, it will begin. Sorry for my part in this. What did you deny me, really, after all? A beautiful year or so, in a lovely place. It would have made me happy. But what is it, a year, in the grand scheme? Nothing. What are ten years, a hundred, a thousand? I am going, friend, I am all but gone, I believe you prideful and wrong but I have no desire, now, to cure you. Your wrongness was an idea I had. I am all but gone. My idea of your wrongness will go with me. Your rightness is an idea you are having. It will go with you. For all of that, I hope you live forever, and if the place falls down around you, as it seems to be doing, I hope even that brings you joy. It was always falling down around you, everything has always been falling down around us. Only we were too alive to notice. I feel the truth of this in my body now. I am trying not to be terrified. But I am sometimes, in the night. If you are a praying man, pray for me, friend. Friend who might have been. Friend who should have been.

That letter exists in my mind. But I am too tired to write it. Well, that is not true. I am not too tired.

I'm just not ready.

The surge of pride and life and self is still too strong in me. But I will get there. I will. I will write it yet. Only I must not wait too long.

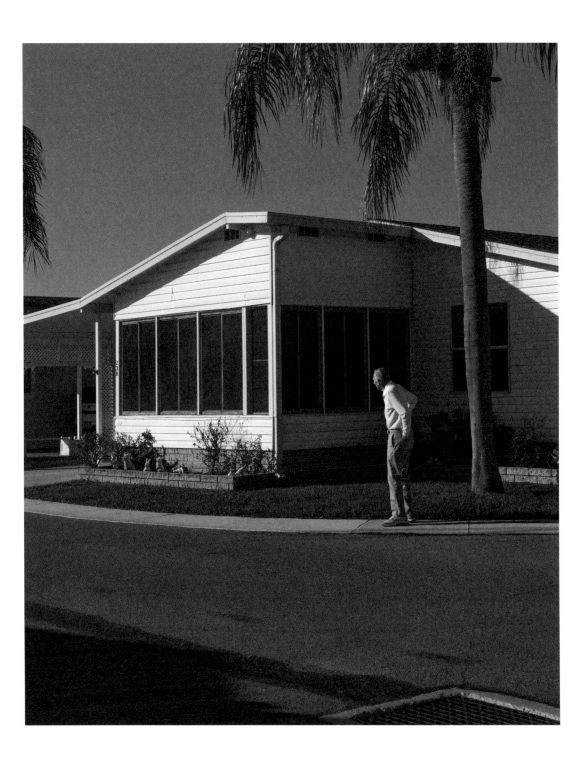

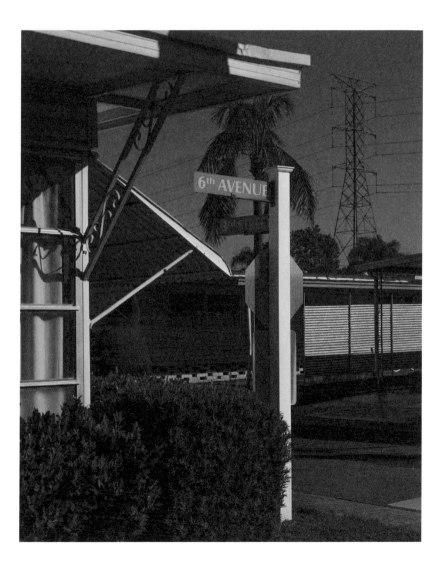

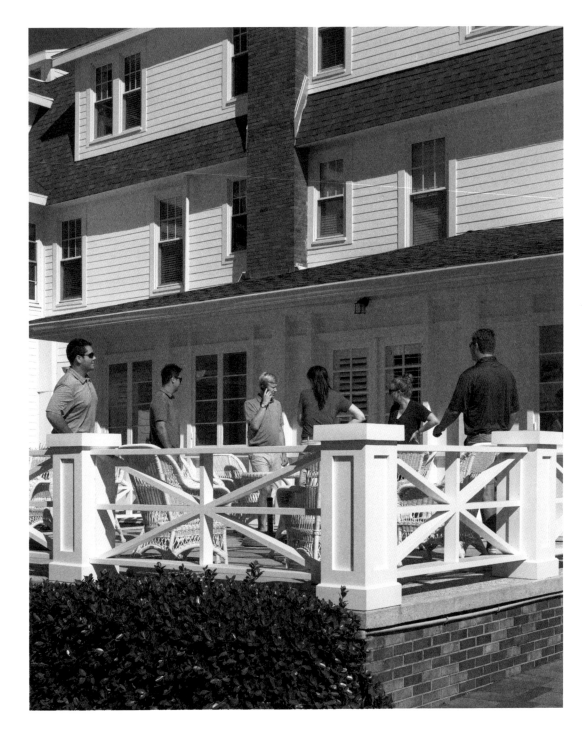

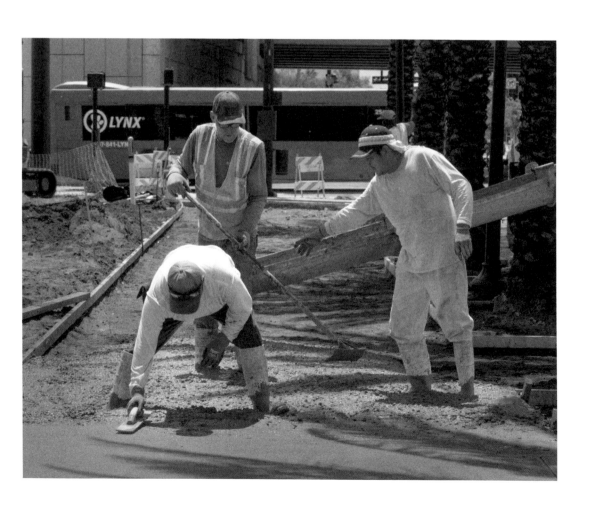

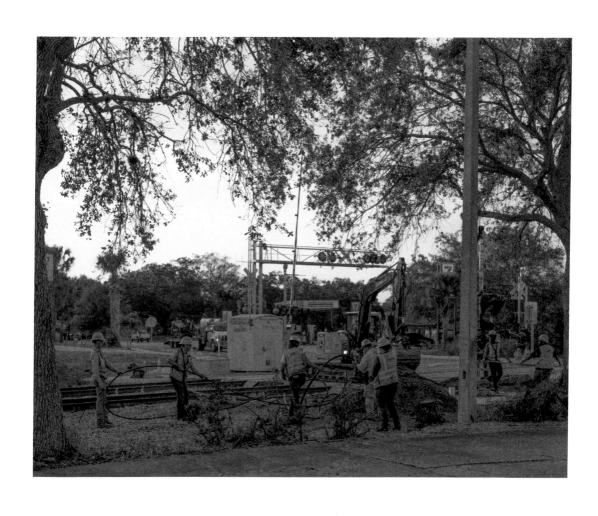

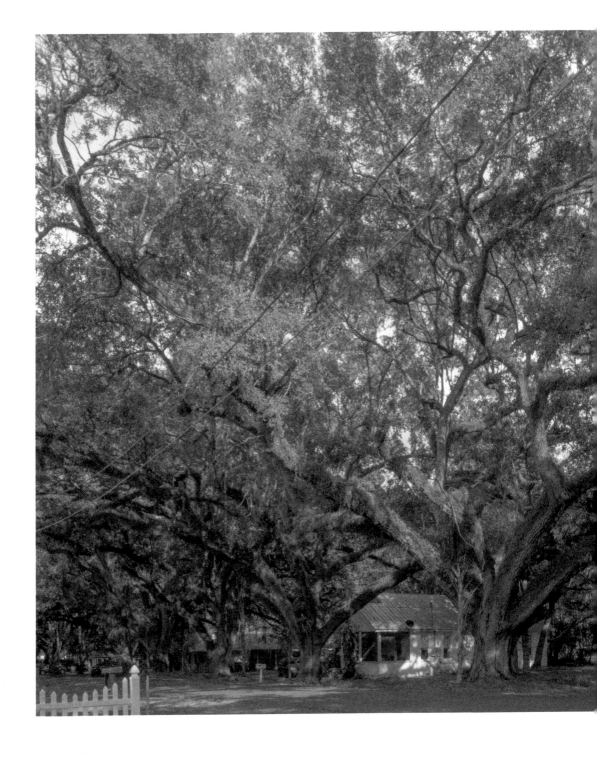

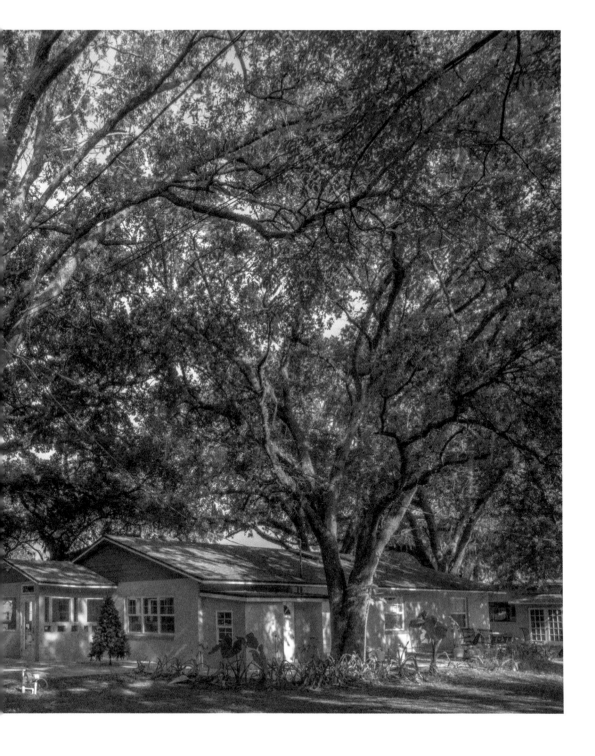

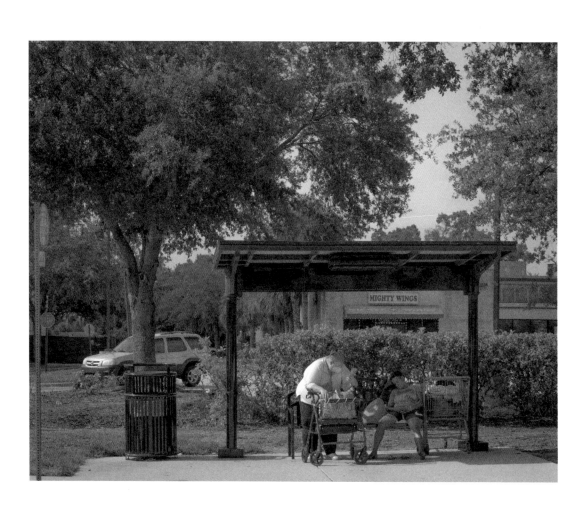

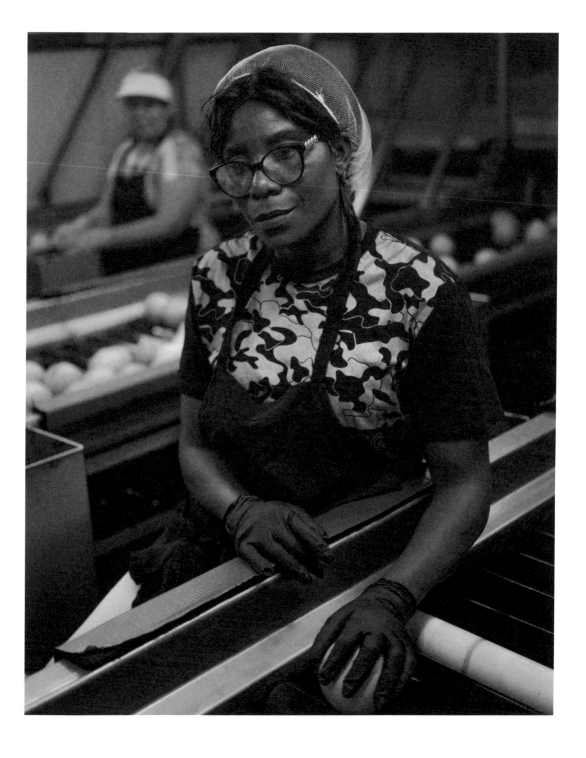

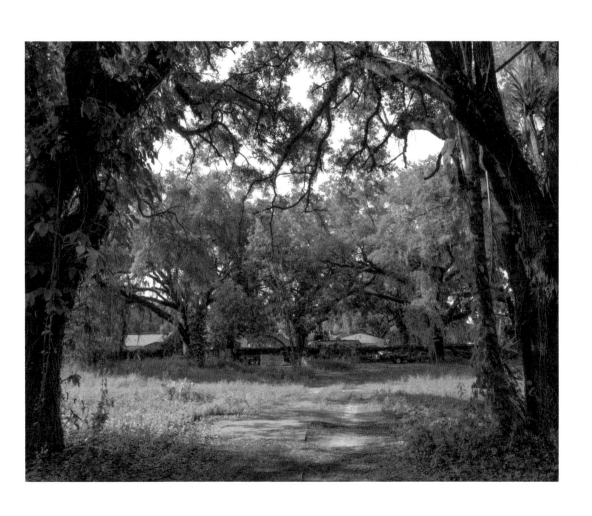

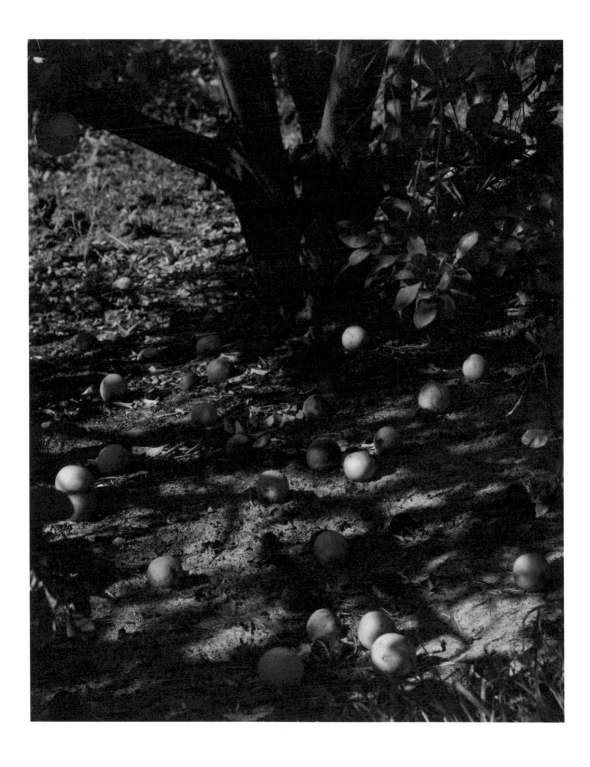

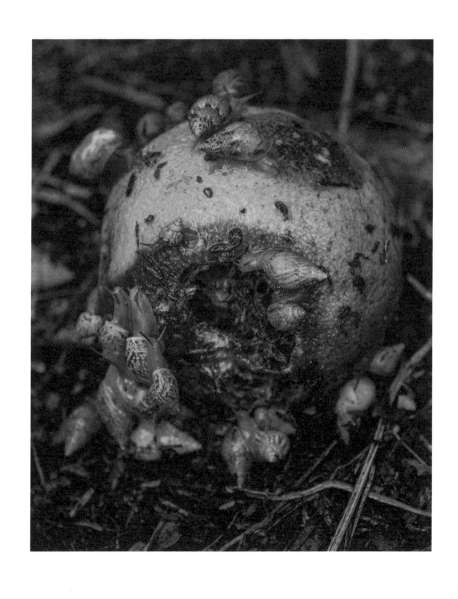